never mind

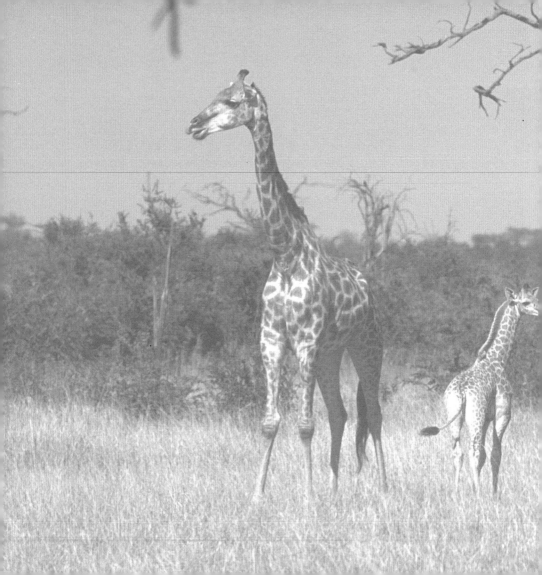

never mind

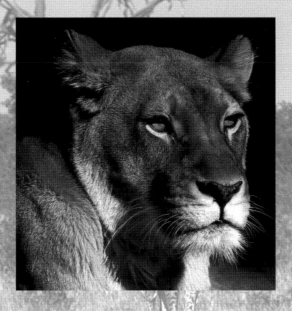

inspiring words for life's difficult moments

edited by tom burns

BARRON'S

First edition for North America published 2005
by Barron's Educational Series, Inc.

All inquiries should be addressed to:
Barron's Educational Series, Inc.
250 Wireless Boulevard
Hauppauge, New York 11788
www.barronseduc.com

Library of Congress Catalog Card No: 2004117788

ISBN 13: 978-07641-5881-0
ISBN 10: 0-7641-5881-3

Conceived and created by
Axis Publishing Limited
8c Accommodation Road
London NW11 8ED
www.axispublishing.co.uk

Creative Director: Siân Keogh
Designer: Simon de Lotz
Editorial Director: Anne Yelland
Production Manager: Jo Ryan

Printed and bound in China

9 8 7 6 5 4 3 2 1

about this book

Life can be stressful, even at the best of times. When it's all too much and things start to get you down for whatever reasons, you need *Never Mind*, a collection of inspirational words which will set you back on your feet and back on the right track. Backed up with gently amusing animal photographs, these words of wisdom, written by real people and based on what they have found to be helpful when they had problems, will help you to see the funny side, accept a setback, take the good from a bad situation, and generally get on with your life.

about the author

Tom Burns has written for a range of magazines and edited more than a hundred books on subjects as diverse as games and sports, cinema, history, and health and fitness. From the many hundreds of contributions that were sent to him by people giving their take on life, he has selected the ones that are most inspirational when life is proving difficult.

Please continue to send in your views, feelings, and advice about life—you never know, you too might see your words of wisdom in print one day!

The right person is
the one who seizes
the opportunity.

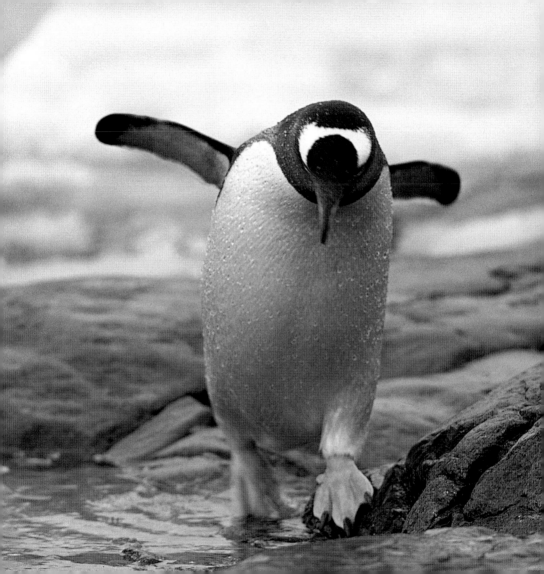

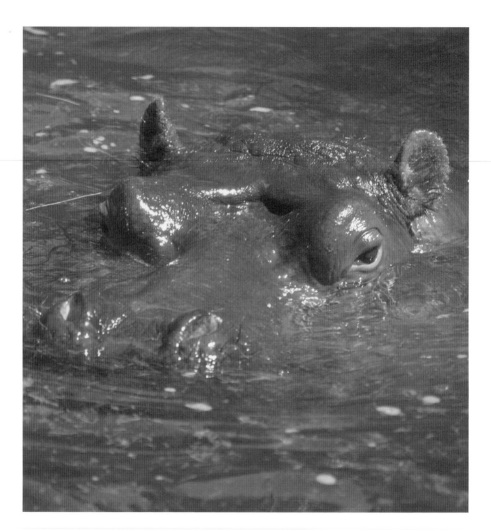

The fish will bite when you least expect it.

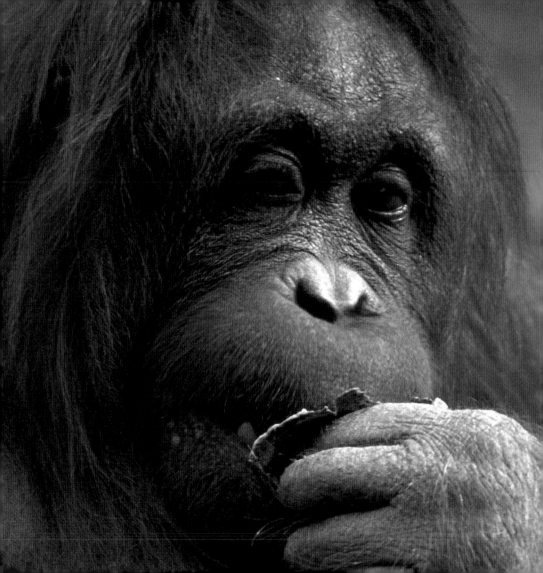

Procastination is the grave in which opportunities are buried.

The door of opportunity
is wide open…

…if you are
prepared for it.

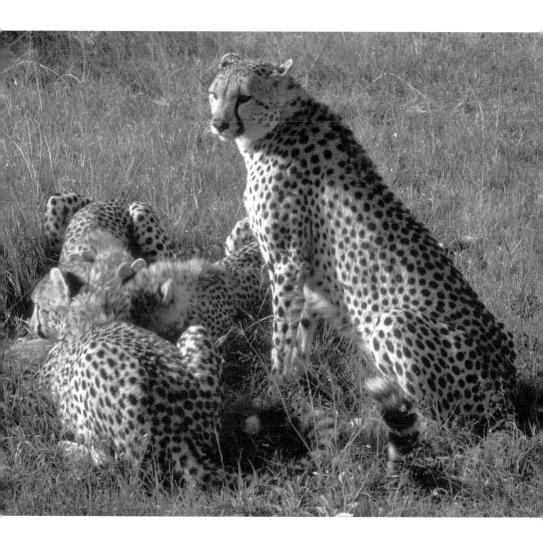

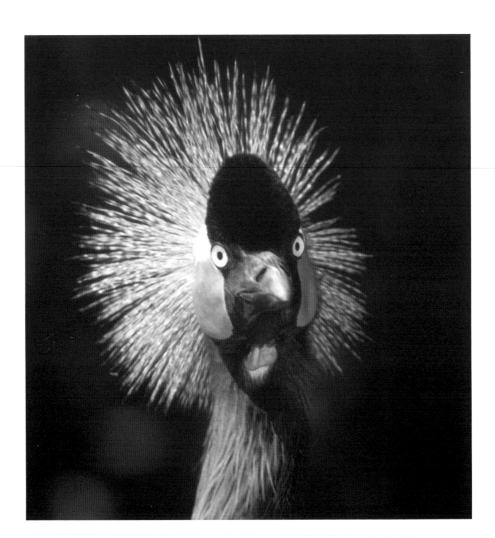

You won't hear the knock on the door if you're wearing headphones.

You can't plow a field by turning it over in your mind.

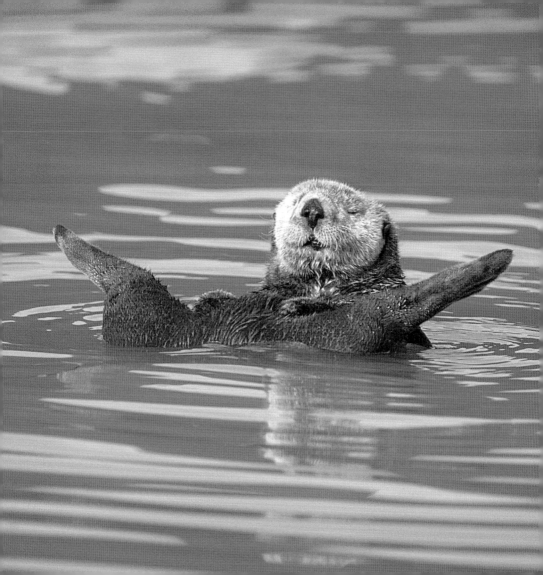

Looking on the bright side
never causes eyestrain.

Opportunities are
never lost…

…someone else
will take the ones
you miss.

Hope is a waking dream.

Vision without action
is just a daydream.

Opportunity often comes
disguised in the form
of misfortune,
or temporary defeat.

Many of life's failures are people who did not realize how close they were to success when they gave up.

The minute you settle
for less than you deserve,
you get even less than
you settled for.

Only the person
of worth can recognize
the worth in others.

No matter how dark
things seem to be, there
are always possibilities.

Opportunities are like buses, there's always another one coming.

An optimist makes
opportunities of
his difficulties.

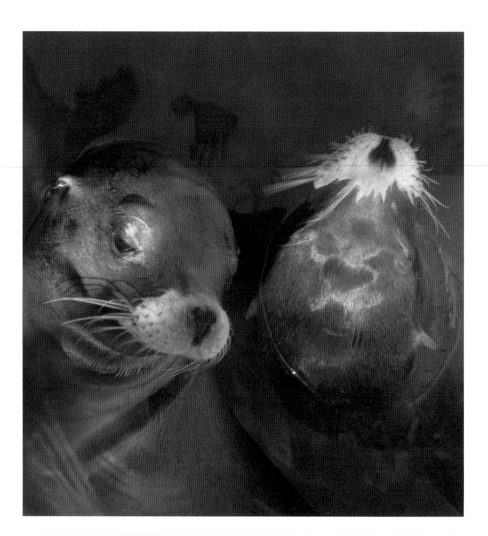

Remain optimistic…

…until they start moving animals in pairs to Cape Canaveral.

No success or failure
is necessarily final.

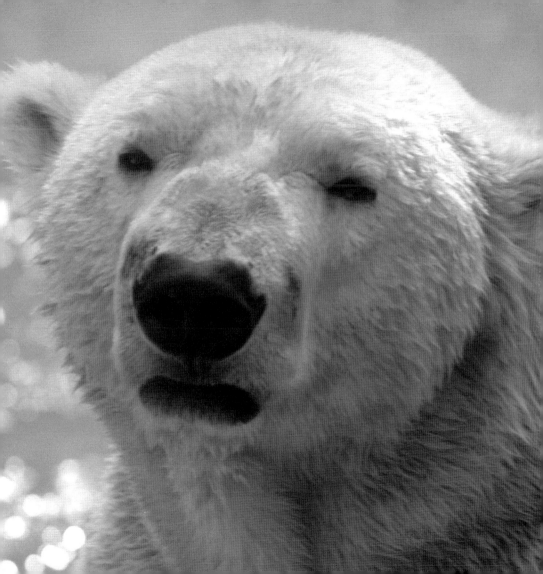

A dead end street is a place to turn around.

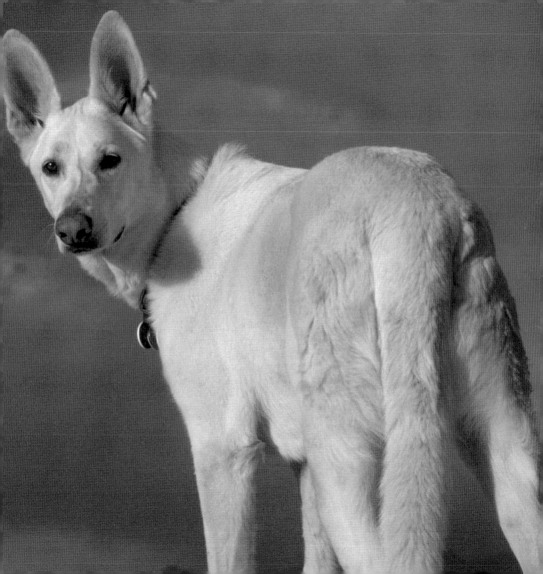

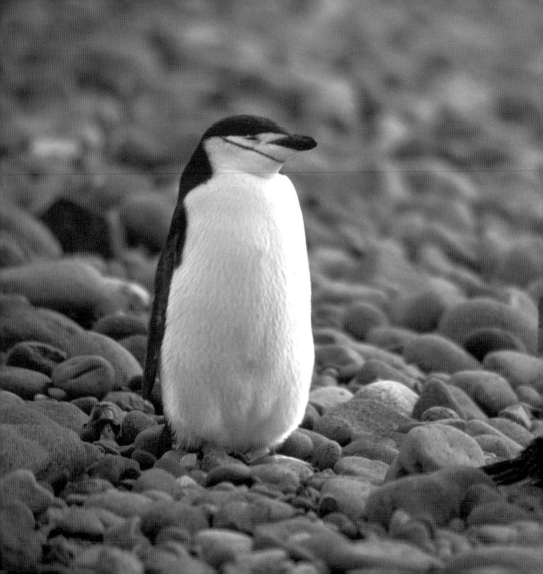

A worthless pebble
is a rough diamond
in disguise.

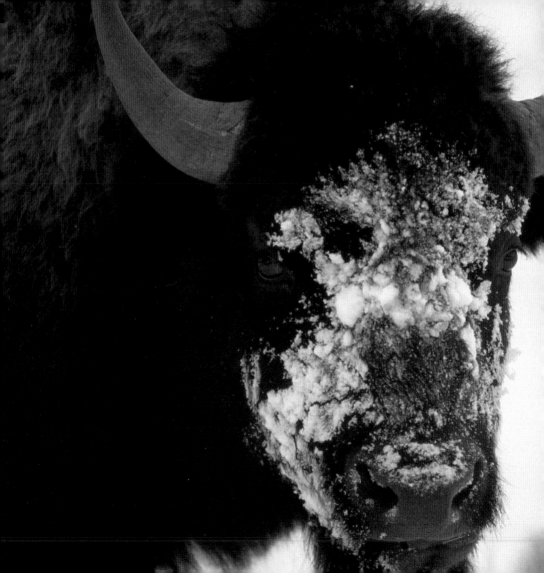

Even in the depths of
winter, there is an
invincible summer.

You can't go back and make
a brand new start, but you
can start over and make
a brand new ending.

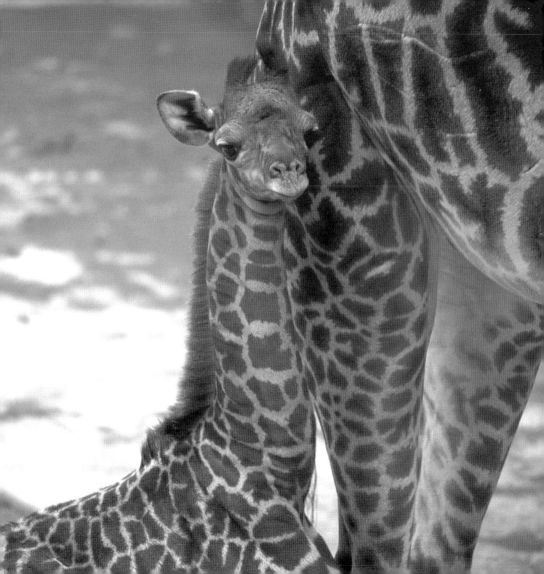

You are an ocean unsailed,
a continent unexplored,
a world of possibilities.

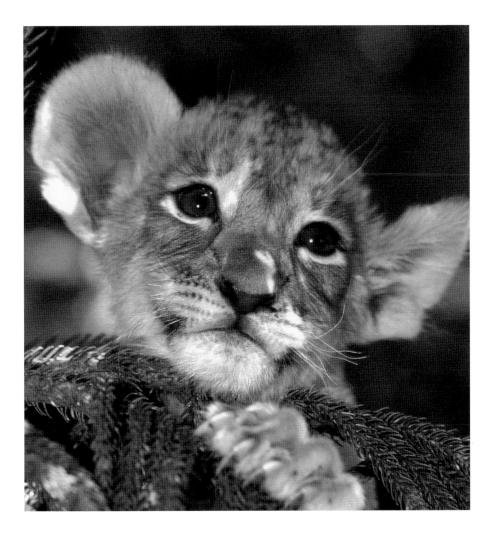

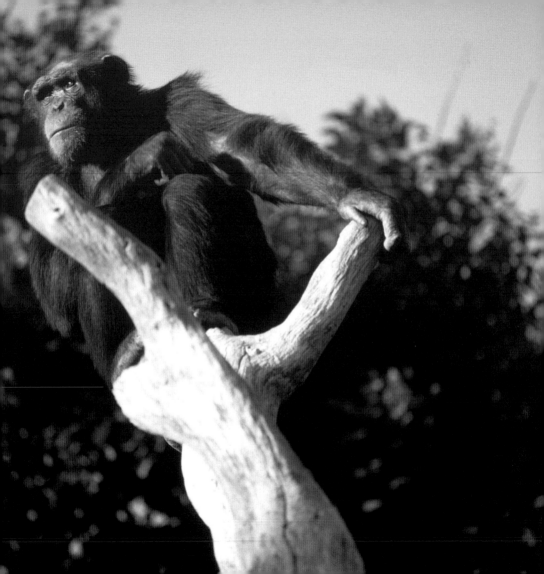

Reach up as far as you can and providence will reach down all the way.

It's not what you
are that matters,
but what you
can become.

You don't know how great you can become.

The only victories worth having are those that entailed a hard fight.

A victory without danger is
a triumph without glory.

It doesn't matter how
many defeats you suffer,
you were still born
to victory.

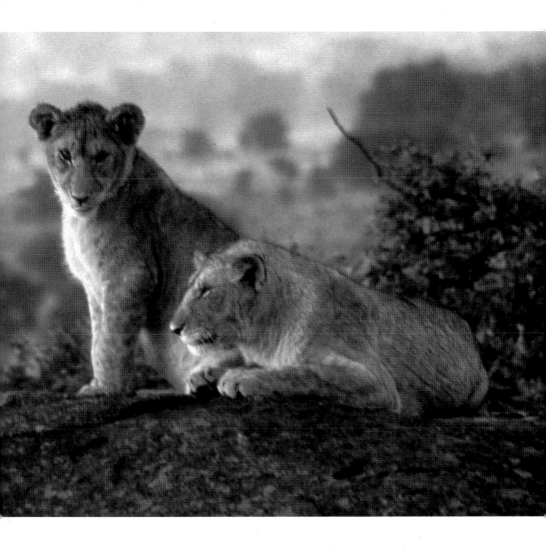

If you don't have time to do it right, you're going to need time to do it over.

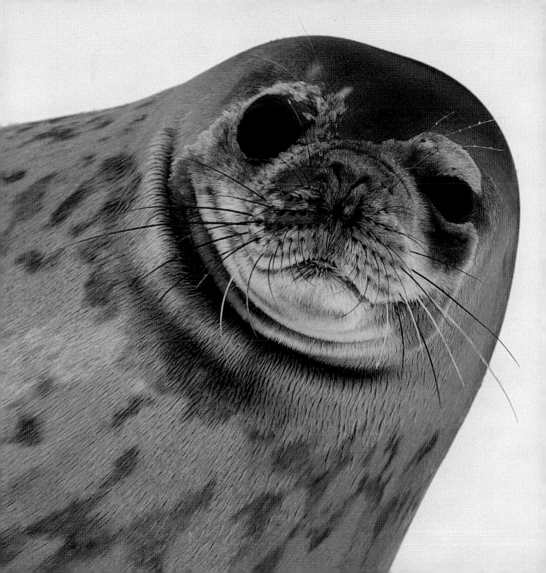

Rock bottom is solid ground.

Nature doesn't hurry,
but everything gets done.

When you feel at your worst is when you get to know yourself best.

Tearing your hair out
only makes you bald.

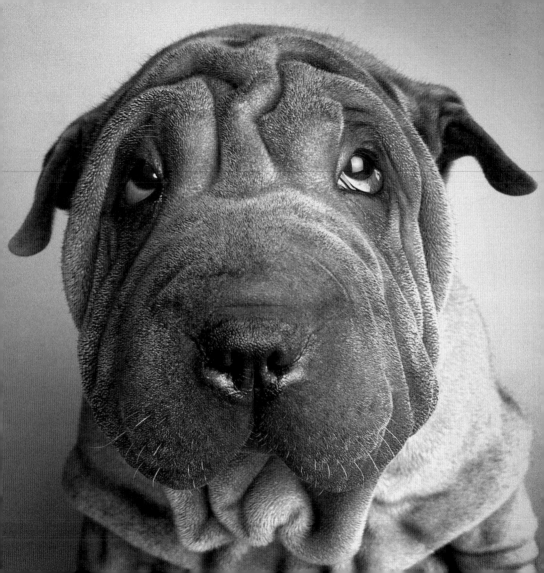

Dreams are a size too big
so we grow into them.

We must all assume burdens, but we were all born with shoulders.

If you cry when the sun goes down you won't see the stars.

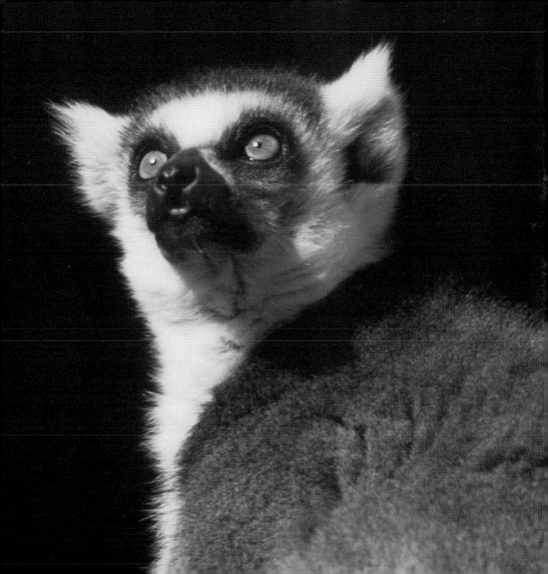

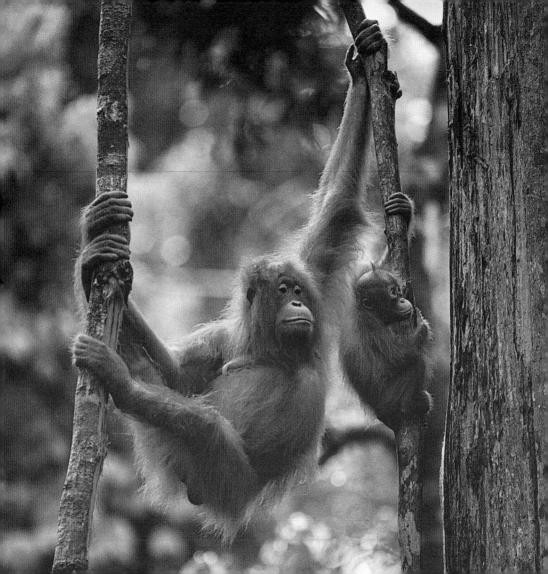

Difficulty is the
nurse of greatness.

Great ideas need wings
and landing gear.

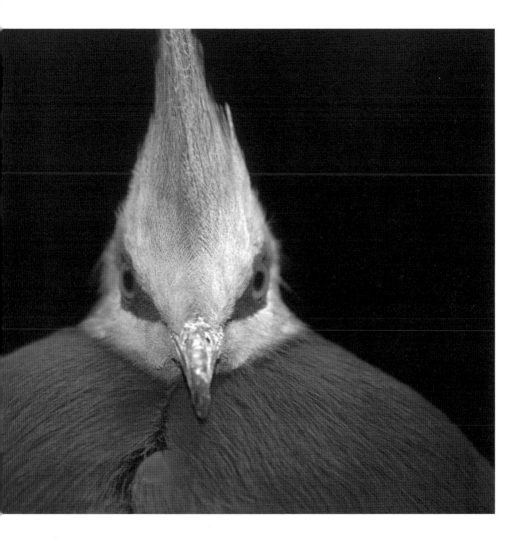

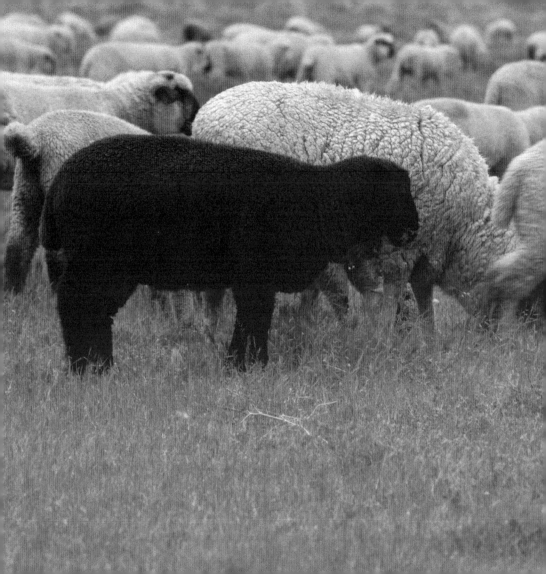

Don't neglect what you
can be by trying to be
something you can't be.

A good scare is worth
more than good advice.

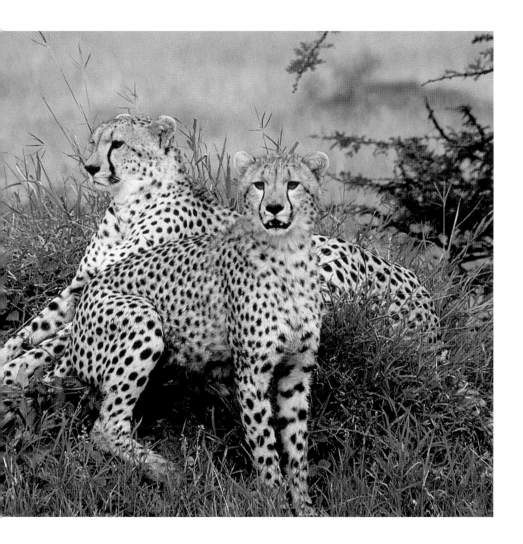

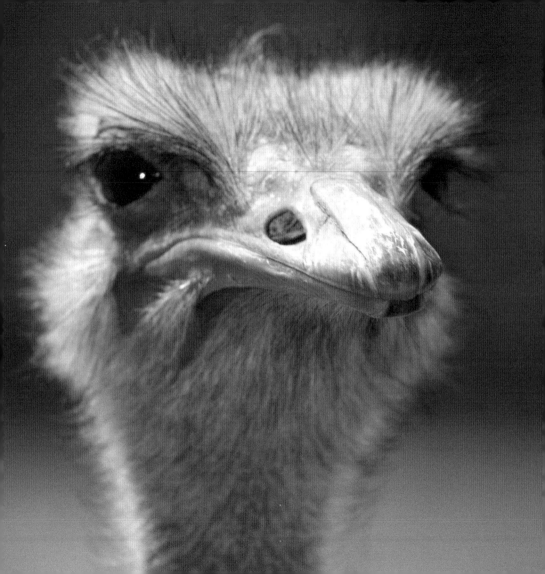

You only hit obstacles when you take your eye off the goal.

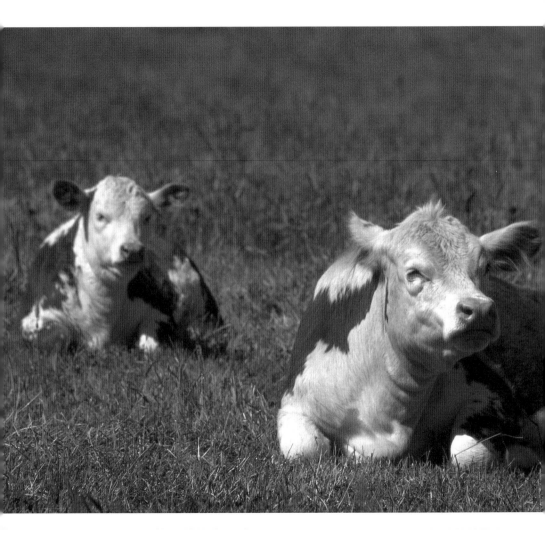

You can't win the race
if you don't run.

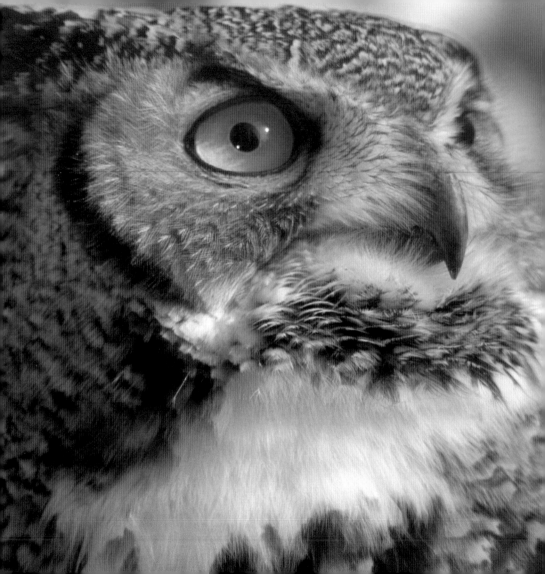

If you only look at what is, you might never attain what could be.

The best is yet to come.

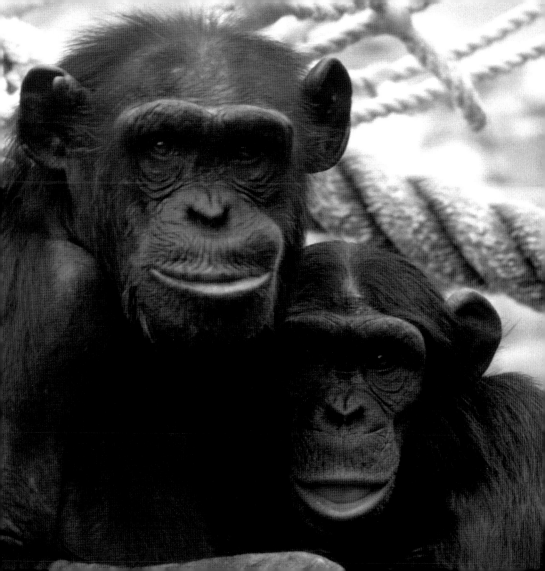

Start viewing the possible as probable…

…you'll be surprised at what you can accomplish.

Today's buts are the only limits to tomorrow's possibilities.

The range of available
choices knows no limits.

No matter how far you go,
the horizon is still
in the distance.

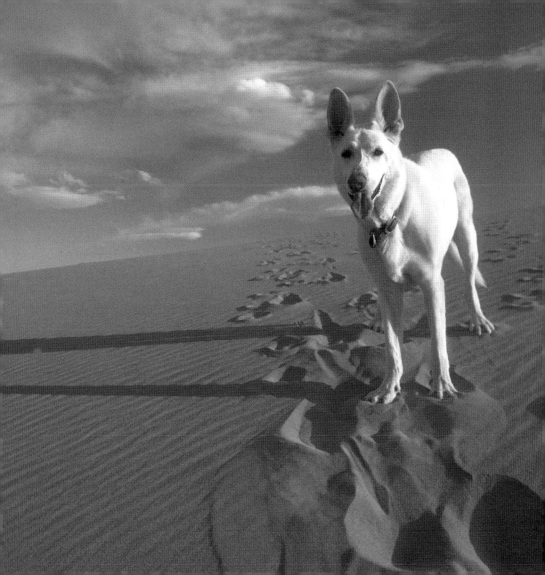

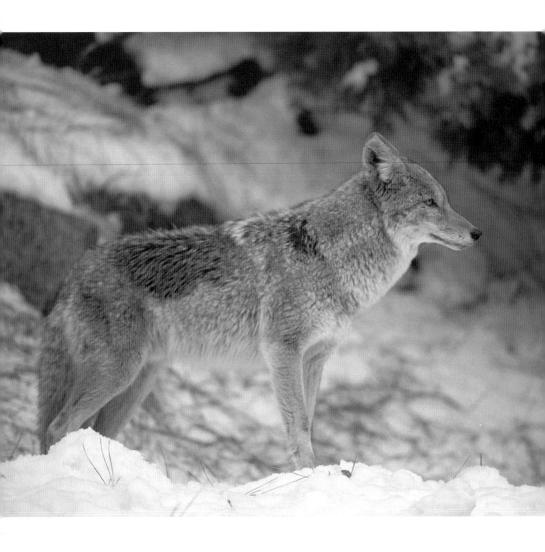

It doesn't matter how high the mountain is, once you've climbed it you realize how low it was.

If you were happy
every day of your
life you wouldn't
be a human being,
you'd be a game
show host.

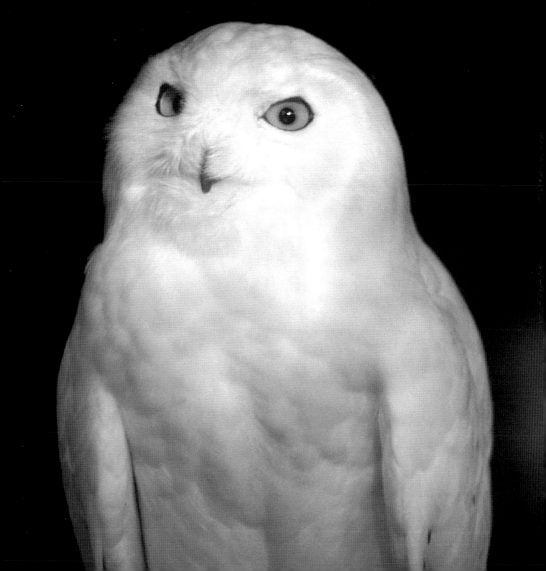

No one of us is born with a
stop sign on their powers
or a limit to their capacities.

If you don't look,
you won't find.

Obstacles are
opportunities waiting
to happen.

The greatest opportunities are often disguised as insurmountable obstacles.

Where there is a willing hand
and an open mind there
will always be a frontier.

Opportunity doesn't knock, it's there all the time, waiting for you to notice it.

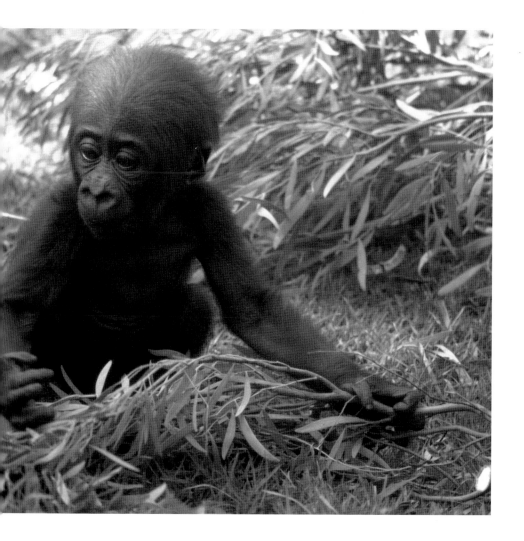

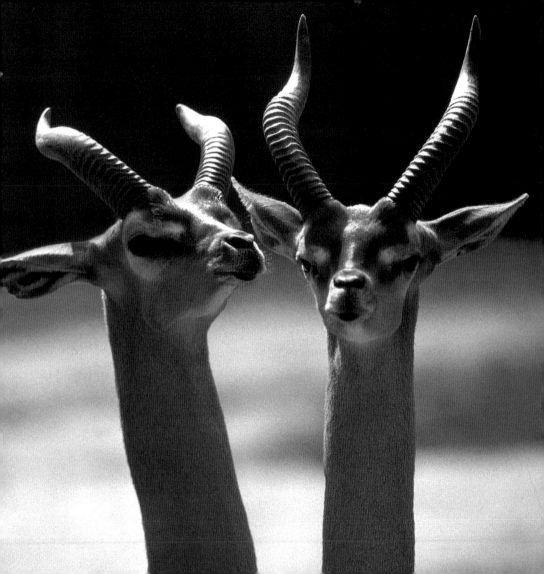